Niki's World

Prestel

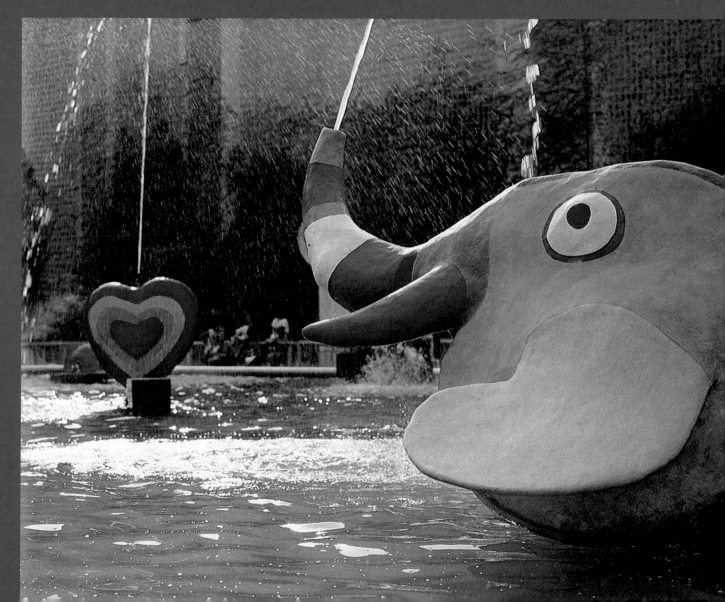

The Elephant and the Firebird

Looking at paintings and sculptures by the artist Niki
de Saint Phalle makes you feel as if you have stepped into
a fairy tale full of secrets and surprises. Come with us
on this journey of discovery and explore Niki's world!

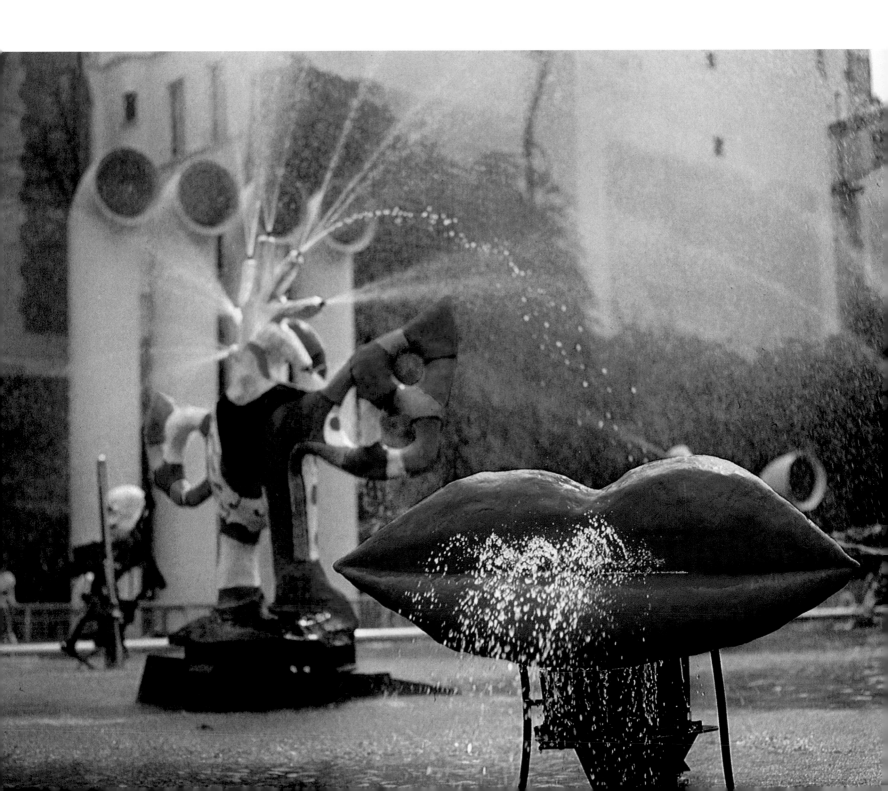

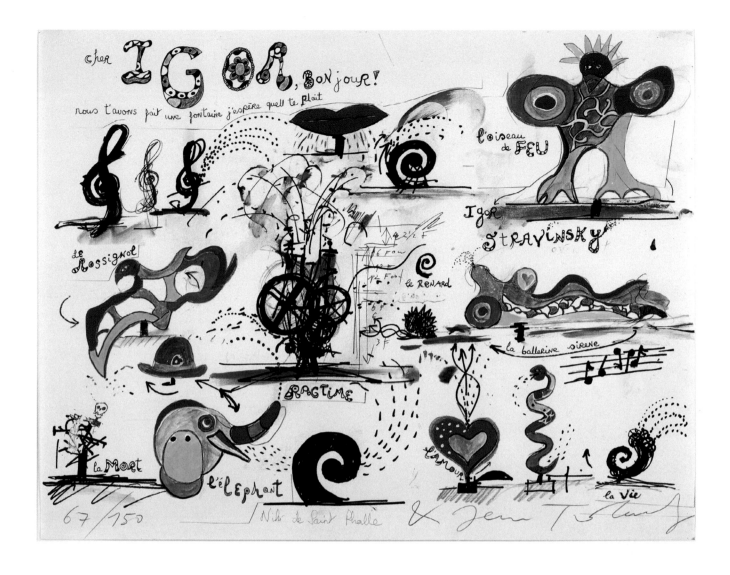

In the middle of Paris, next to the Pompidou Center, is the Stravinsky Fountain. It is very big and is full of figures turning around and spurting water. The fountain is named after the composer Igor Stravinsky. The figures were made by Niki de Saint Phalle, and the squeaking cogs, wheels, and water-spraying machines were invented by her husband and friend, the Swiss artist Jean Tinguely. The fountain was inspired by Stravinsky's ballet called "Firebird."

This drawing shows some of the designs sketched by Niki and Jean for the figures that make up the fountain. Can you find the elephant and the firebird which appear in the photos on the previous pages? The water-spouting mouth is also there, as are a mermaid, a nightingale, a treble clef, a heart, and lots of other things. The skull at the bottom on the left is a symbol of death, whereas the squiggle on the far right is a symbol of life.

3

Dragons and Heroines

When Niki was a little girl, she loved stories about dragons. In Grimm's fairy tales there are some stories of fierce monsters who were slain by bright and beautiful maidens. Bold knights and heroes might be one thing, but maidens and princesses who are always on the winning side were something quite different. They became her heroes just like the supergirls she liked to read about in her comic books when she was a bit older.

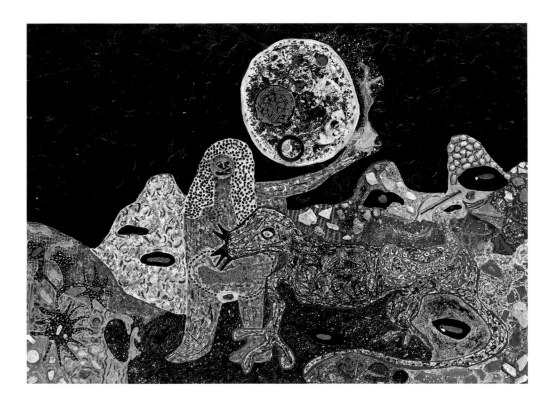

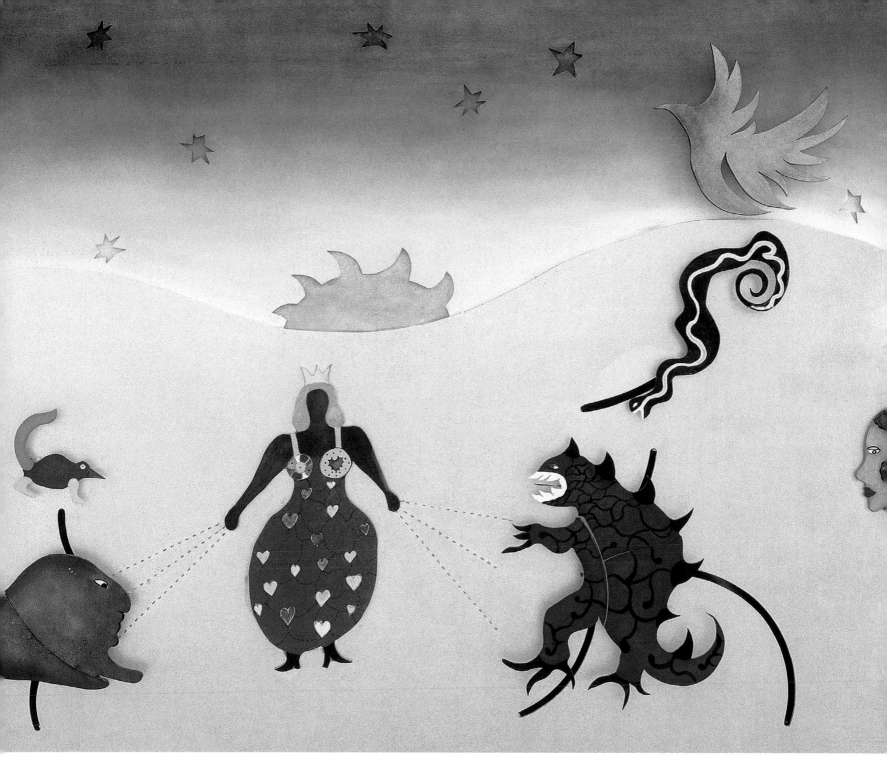

Queen Califia

For the last few years of her life, Niki returned to America, to California. There the tale of Queen Califia is sometimes told—a queen who was as black as the Ace of Spades and the most beautiful of all women. She was adorned with gold armor and rode an eagle. She also had a pack of wild dogs who obeyed her every command. This picture shows her as the ruler of all animals—including those she was afraid of such as snakes. She even succeeded in taming lions and dragons, too.

5

The Nanas

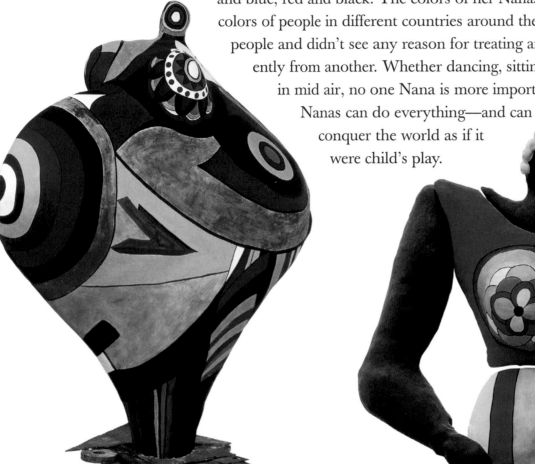

Niki's most famous heroines are the Nanas. She invented these large, feminine, brightly-colored women nearly forty years ago, and painted them yellow and blue, red and black. The colors of her Nanas are as varied as the colors of people in different countries around the world. Niki loved people and didn't see any reason for treating any one person differently from another. Whether dancing, sitting, standing or floating in mid air, no one Nana is more important than any other. Nanas can do everything—and can conquer the world as if it were child's play.

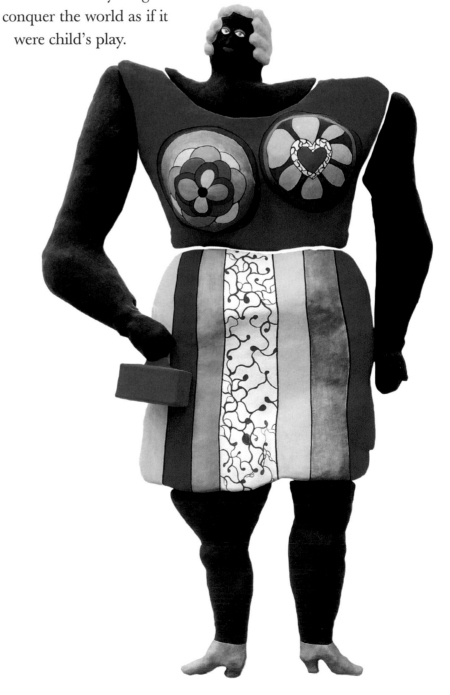

6

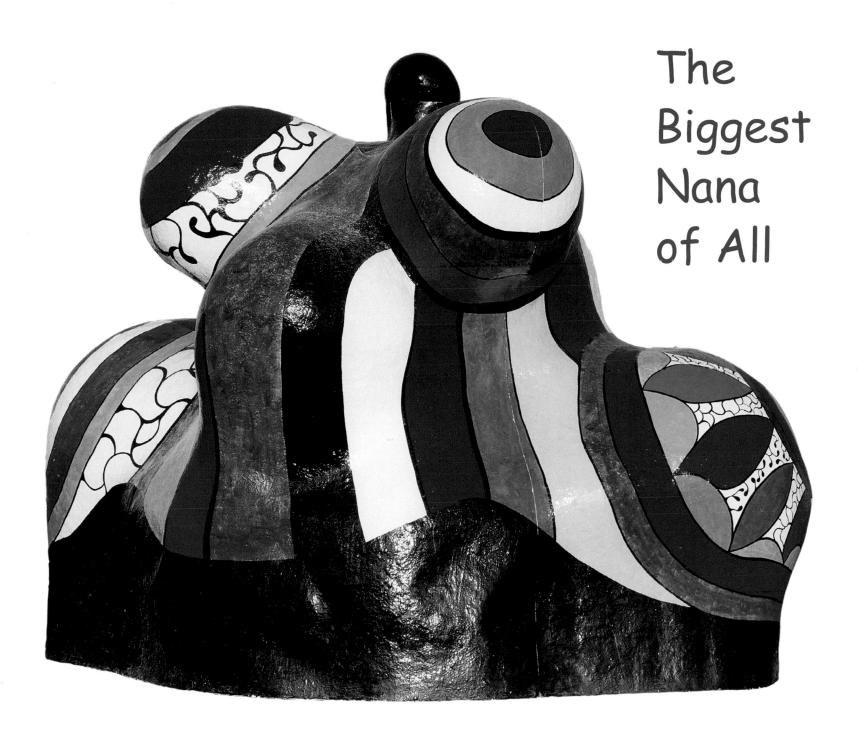

The Biggest Nana of All

Some Nanas are as small as matchboxes, and others are as big as houses. You can actually go into the Nana House shown here, and can sit down and have a rest! Inside, it is blue and peaceful; it feels like being in a cave, sheltered from the sun and the rain. This is a place where you could tell wonderful stories—or make up new ones.

Bon Appetit!

This Nana is stuffing herself with food, complaining about her aches and pains, and about getting old. The little dog is her only companion. That may seem a bit lonely, but in spite of everything, this elderly lady is still full of the joys of life. You can tell that by looking at her face.

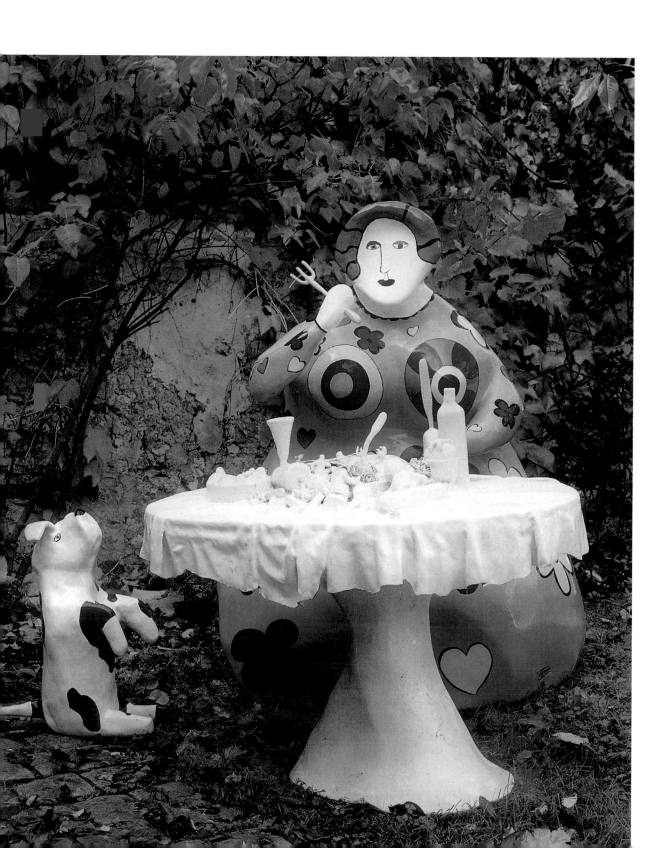

It's not really scary!

Imagine crawling inside this enormous skull. Only a little bit of light comes through the gaps between the skull's teeth, and sitting down inside, it might make you think a little about how wonderful life really is.

The artist made this skull when she was living in southern California, not far from Mexico. Niki liked the cheerful way in which Mexicans deal with the subject of death. Whenever they tend their graves, the whole family goes along to the cemetery for a picnic, and the children even eat candy made in the shape of a skull!

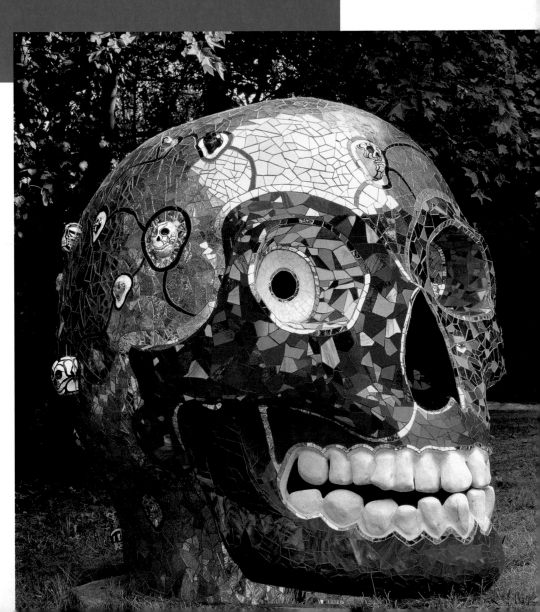

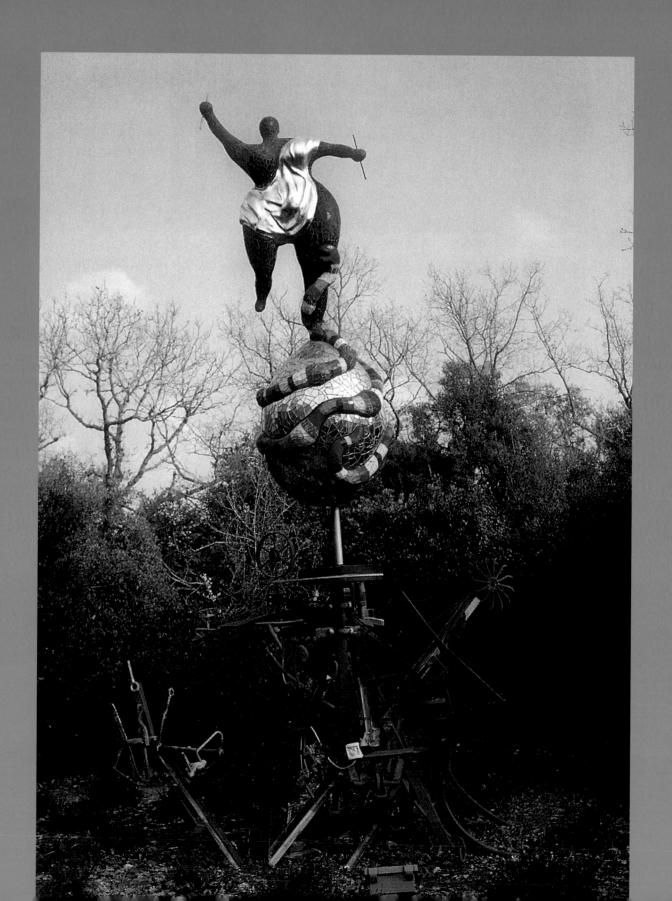

Secrets

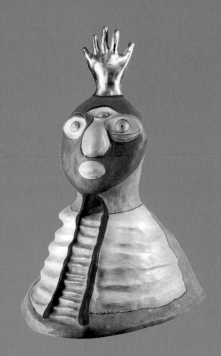

In southern Tuscany in Italy, in a place called Garavicchio, is the Tarot Garden which took Niki de Saint Phalle more than twenty years to complete. In this magic garden there are lots of strange and wonderful figures, inspired by the pictures on old tarot cards. Tarot cards are still used today by lots of people for fortune telling.

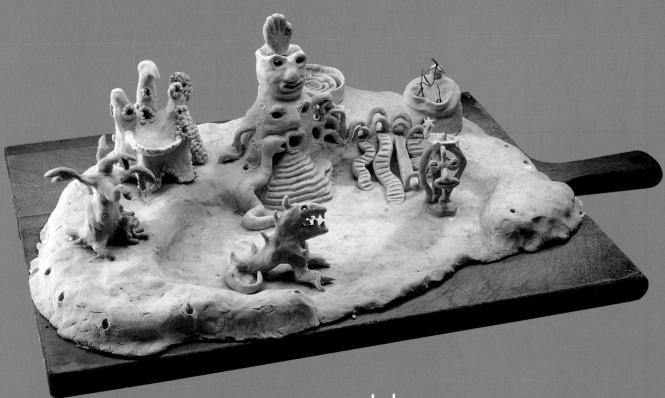

This **model** on a breadboard shows Niki's first idea for the garden. But since then, several new figures have been added.

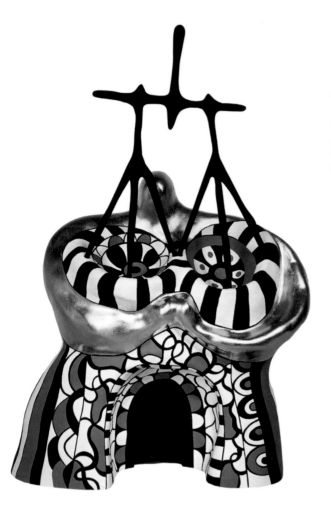

This model is of a big woman with a pair of scales—a symbol of justice, of weighing things up properly. In the Tarot Garden figure, Niki tucked another sculpture into the space under the skirt.

The figure of the **empress** looks like a sphinx—a goddess which is half animal and half human. You can actually go inside the enormous figure in the garden and have fun in a hall of mirrors.

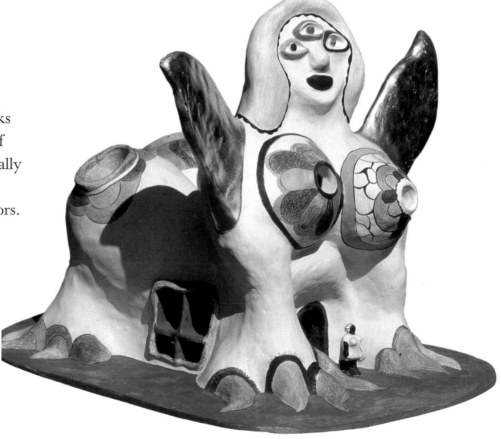

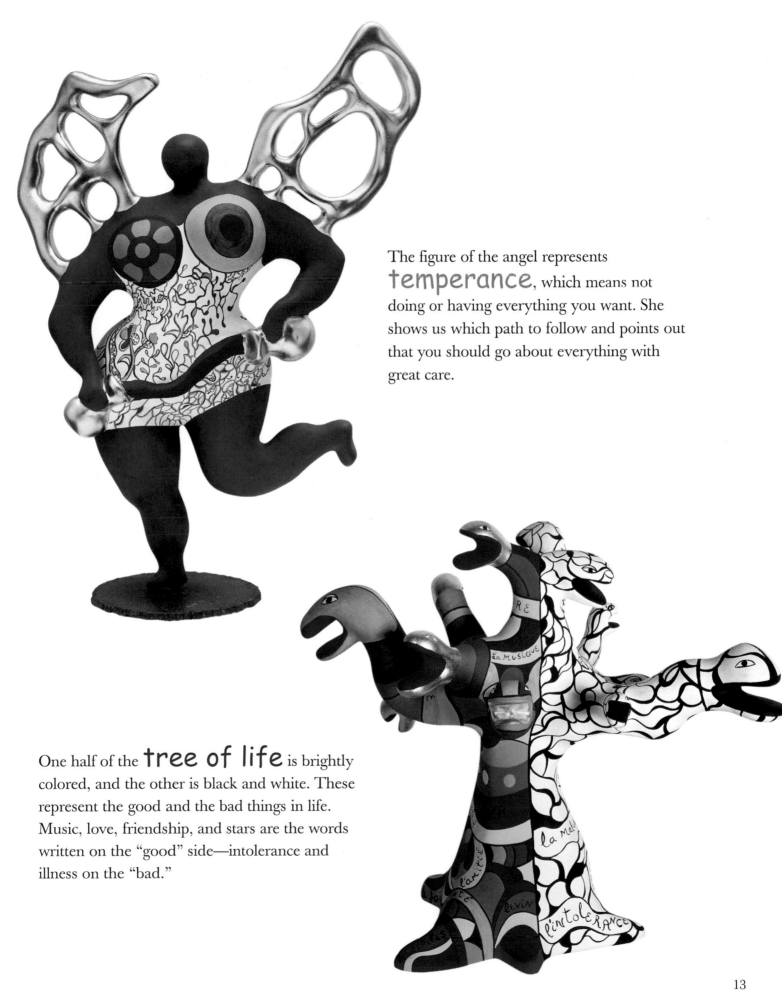

The figure of the angel represents **temperance**, which means not doing or having everything you want. She shows us which path to follow and points out that you should go about everything with great care.

One half of the **tree of life** is brightly colored, and the other is black and white. These represent the good and the bad things in life. Music, love, friendship, and stars are the words written on the "good" side—intolerance and illness on the "bad."

In the middle of this picture drawn by the artist, you can see the figure of the High Priestess, and on the left is a dragon and the empress as a sphinx. Behind them is the Tower of Babel after being struck by lightening. And what are the figures on the right at the top? Turn back a page to find them!

The photo on the right shows us what the garden looked like before it was completed. In summer, water now spouts out of the High Priestess' mouth and runs down the steps into a pool where Jean Tinguely's "Wheel of Fortune" turns round and round. Can you spot it in the drawing?

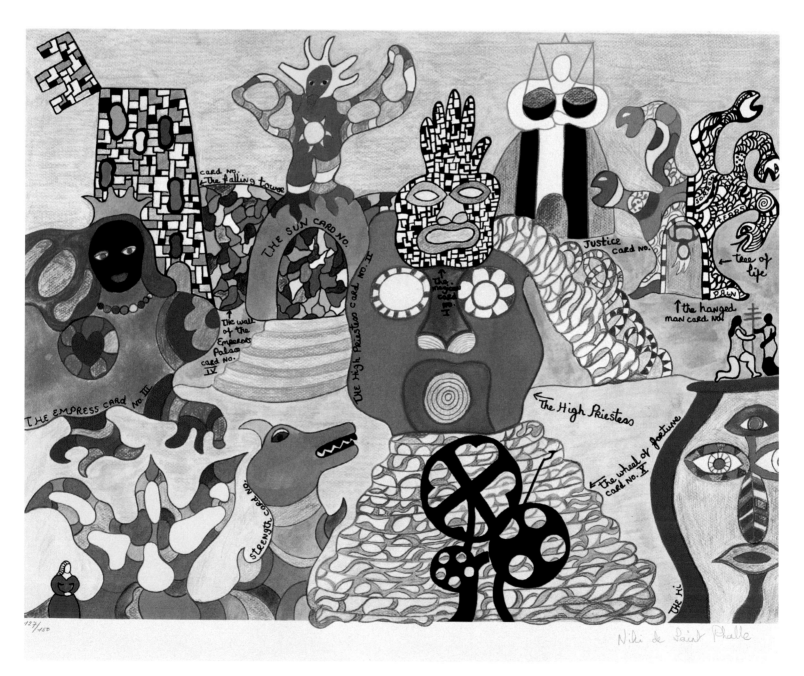

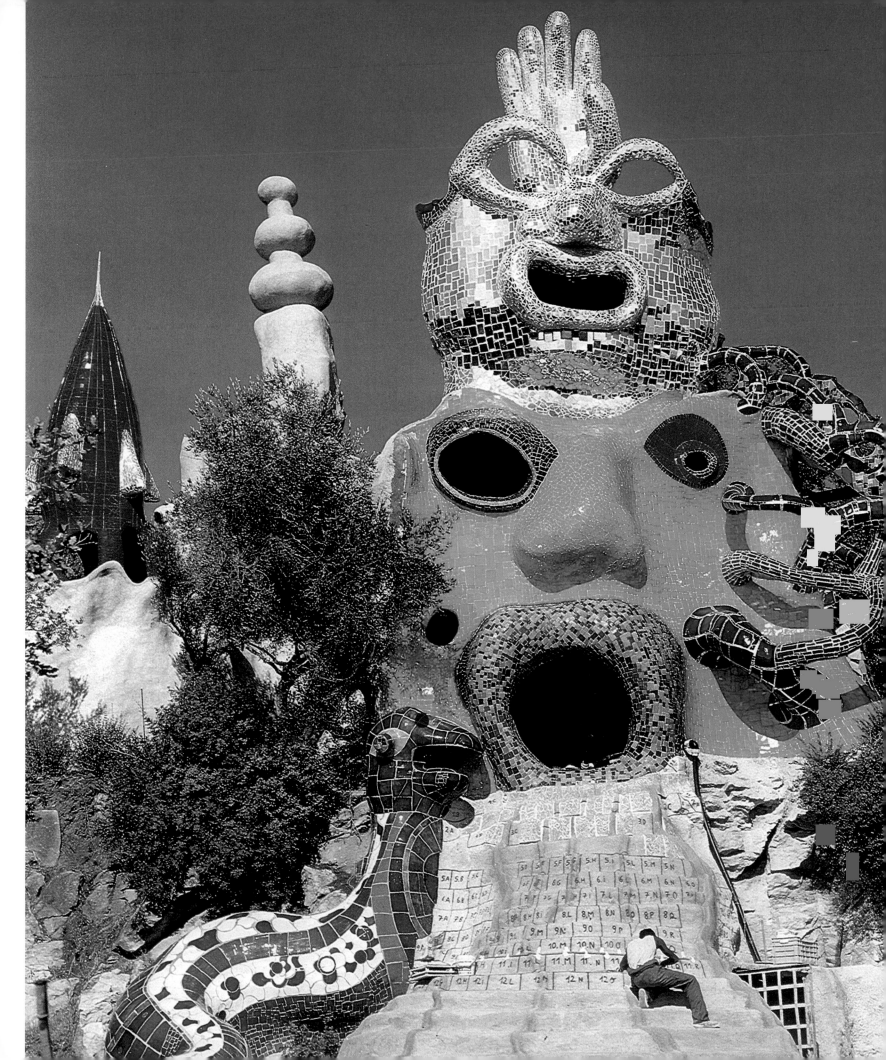

No Grown-ups Allowed !

Niki created a number of sculptures just for children. The first one she made for them is in Jerusalem and is called "The Golem," which is the name of a monster in an Israeli fairy tale. This creature has three tongues—and all of three of them are slides! Jerusalem is a holy place for many people of different religions—for Jews, Christians, and Moslems. This is why Niki drew a Christian church in her plan next to the mosque. At the bottom you can see an Arab and a Jew, with children playing around them. Niki dedicated her Golem sculpture to all the Jewish and Arab children in Jerusalem.

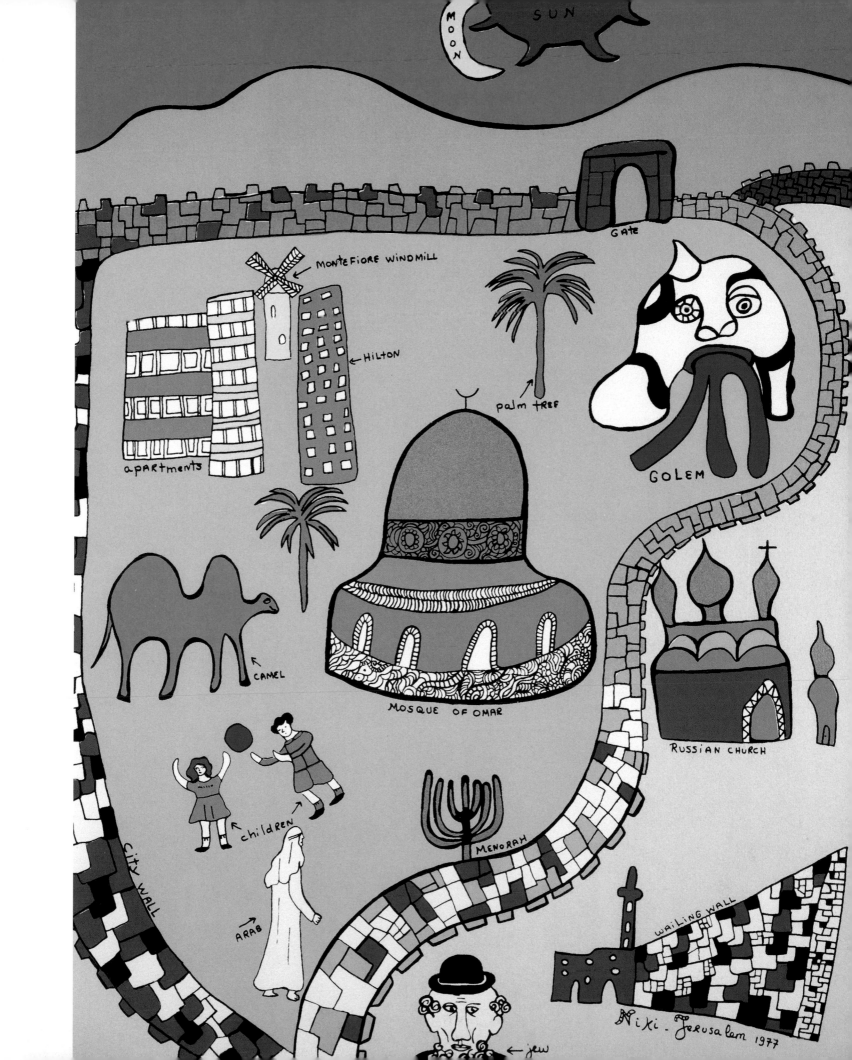

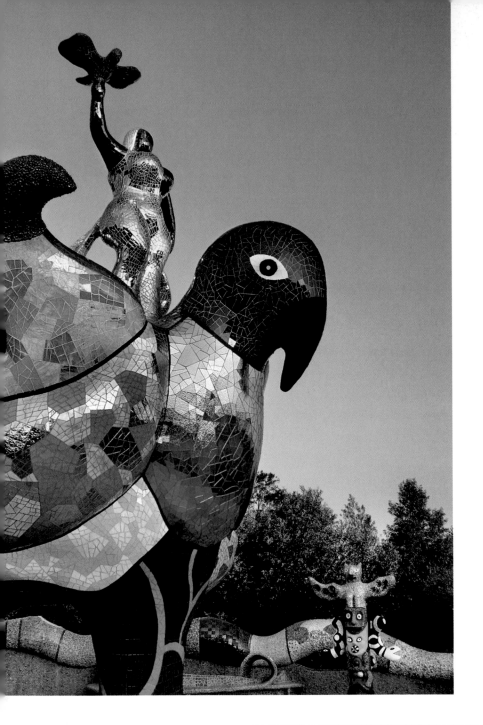

Niki's Magical Mosaics

Niki had been fascinated by American Indian culture for years and when she moved to La Jolla in 1993 she became interested in the origins of California. She collected rocks of all colors and an amazing variety of glass and mirrors which became her new palette, and set about creating *Queen Califia's Magical Circle* in Escondido, California. She even had the totems approved by Native Americans who also offered to help her place them in the correct position. After Niki's death, work on this sculpture garden was continued, and it was opened in October 2003.

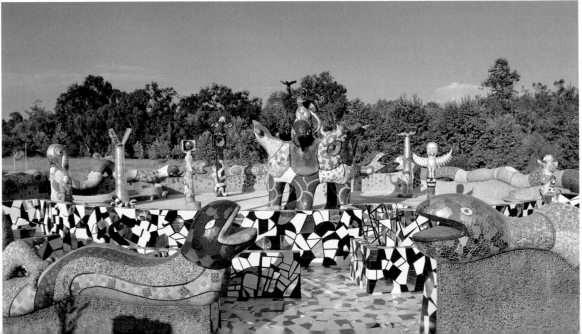

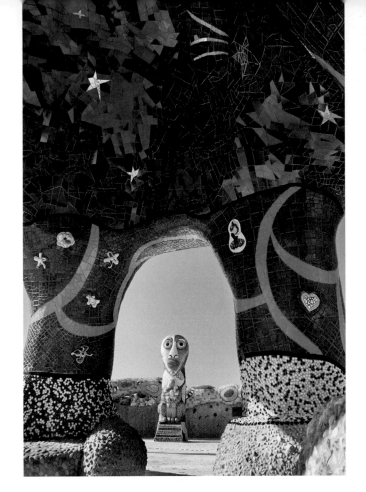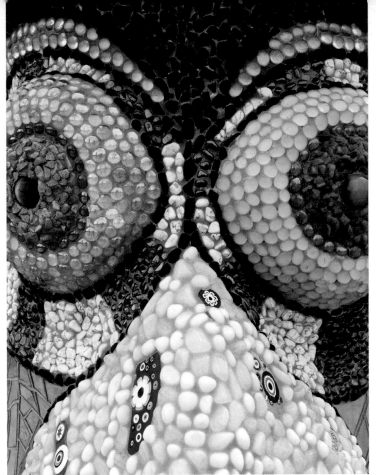

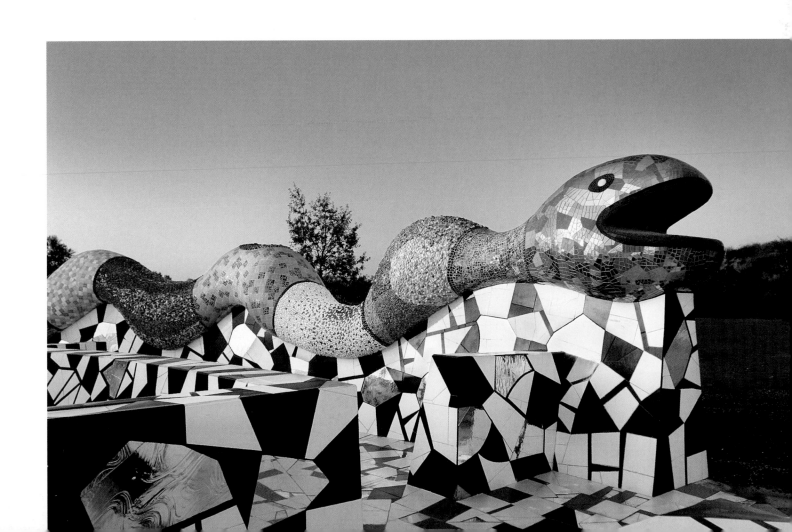

The Colors of Anger

What do you do when you're angry? Niki shot at balloons and cans filled with paint which she had fixed onto her works of art. Bang! When they burst, the paint went all over the white background and dripped down to the floor! She called these pictures "shooting paintings." Through these works Niki wanted to show how unfair things could be in the world and how violent too. She shot at them in order to show people that they had to do something to help make the world a better place.

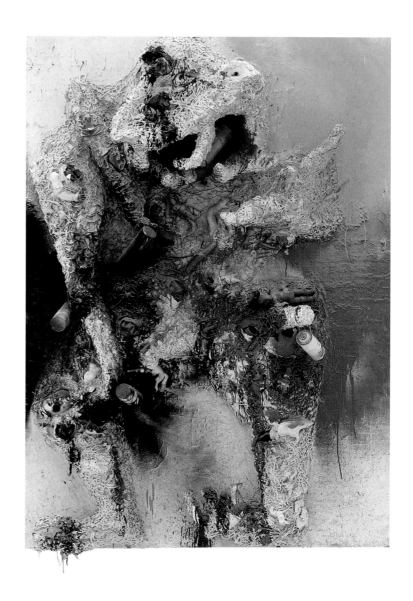

AIDS

Aids is a very dangerous disease which caused the death of some of Niki de Saint Phalle's closest friends. Niki made a book about AIDS for her children Laura and Philip, telling them how they could protect themselves from catching the disease. She also listed some things they didn't have to worry about at all.

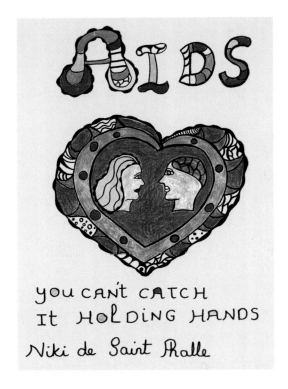

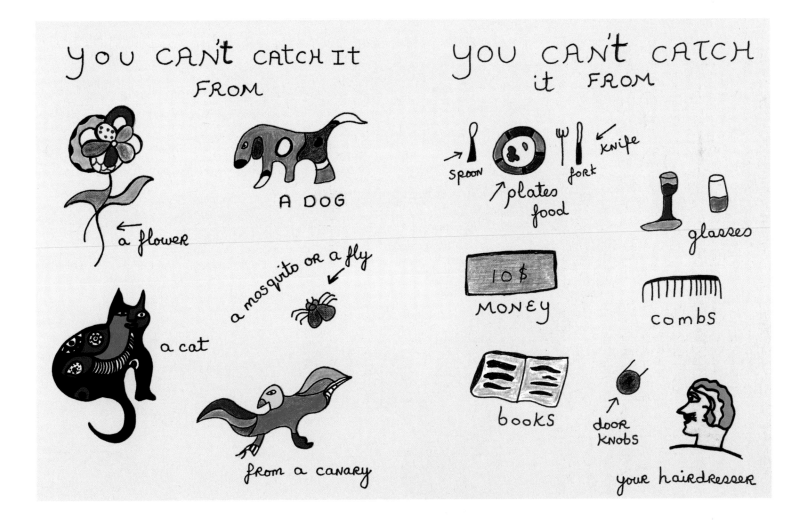

Black Heroines and Heroes

When Niki was growing up in America, blacks and whites were not allowed to mix. But Niki didn't just paint her Nanas white; they were also red, yellow, and black—as black as some Americans who are also known as Afro-Americans. The mid to late 1960s, when the Black Nana (shown here) and other black figures were made, was an important time during which blacks and other colored people struggled to be given the same rights as whites.

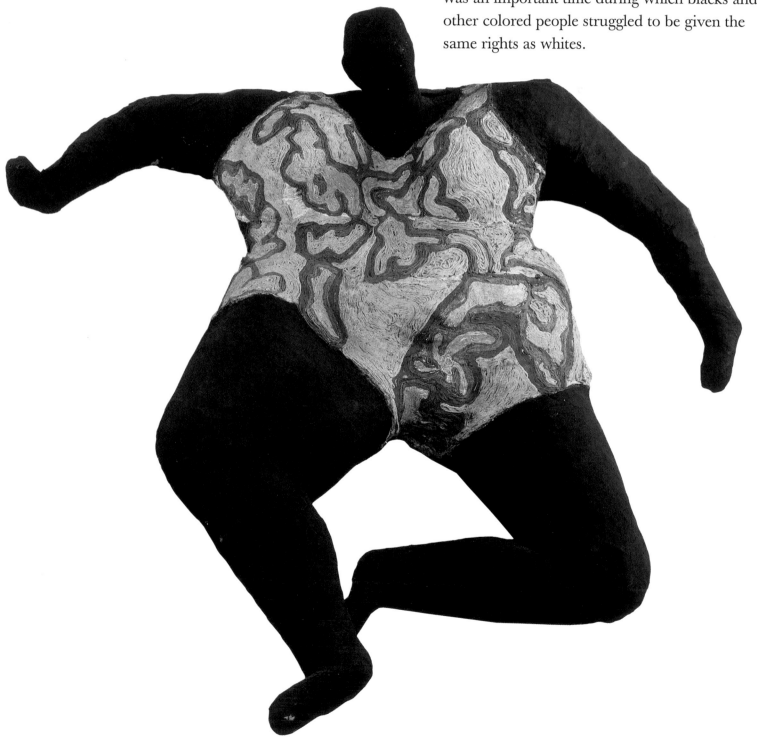

Niki kept a diary, and in it she wrote about making black figures and about her great-grandson.

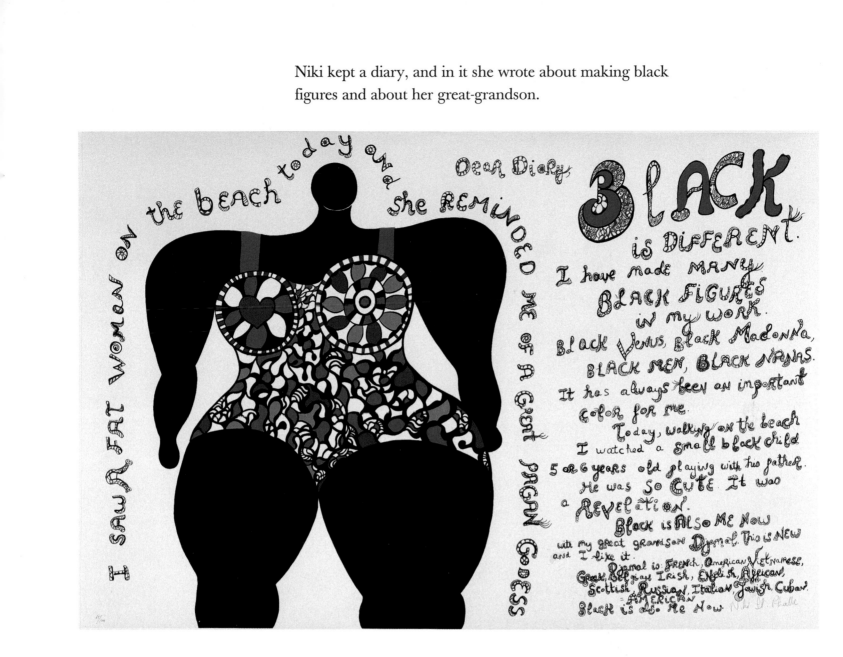

A number of years ago, Niki began to make a series of figures which she called her black heroes—black musicians, sportsmen, and actors. She made these figures for her mixed-black great-grandson Djamal.

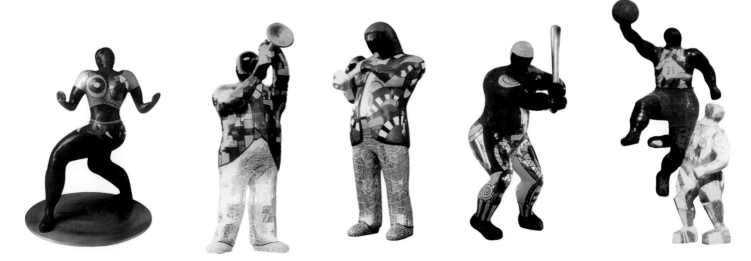

Who was Niki de Saint Phalle?

A painter

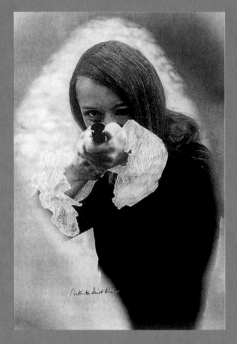

The creator of the "shooting paintings"

An actress

A model

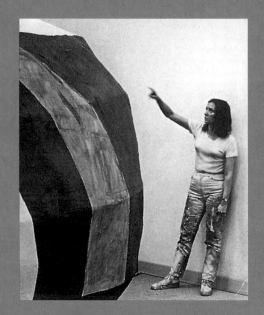

A sculptress

The inventor of the Nanas

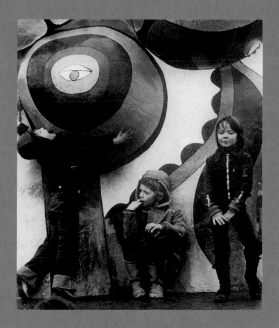

A lover of children

Niki de Saint Phalle was born in France in 1930. She grew up in America and lived in several different countries in Europe, returning to America, to California, later in life, where she died in 2002. She had two children, and lots of grandchildren and great-grandchildren.

A mother, grandmother, and great-grandmother

A thinker

A "Grande Dame"

A superstar

Some of the things I love ...

my children

DOGS

water

POEMS
T.S. Elliot
AKNATOVA
William Blake
KAVAFY

N.Y.C.

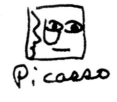
Picasso

Mozar.
Liset
BACA
BEATLES

↑pink

my friends

land of the spirit
INDIA
Indian music

SUN

flowers

Rembrandt

← blue

the mountains
St. Moritz

butterflies

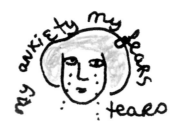
my anxiety my tears

 fairy tales

And what are some of your favorite things?

 Egyptian art and furniture

DeaR DiARy

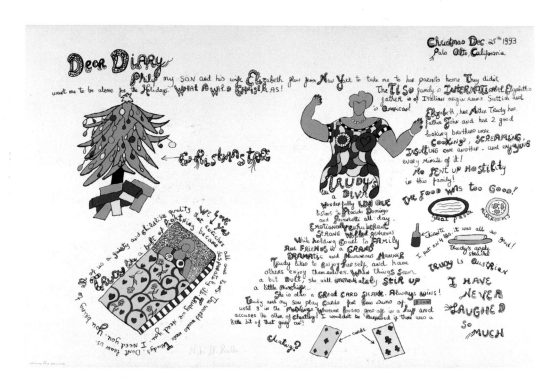

Whenever Niki was happy or sad, or when something exciting had happened, she wrote letters in picture form, like this. Can you guess—without reading the words—what Niki is talking to her diary about in this letter?

DeaR DiaNA

Niki is telling her friend Diana about a shopping trip.

Have you ever sent a letter like this to any of your friends?

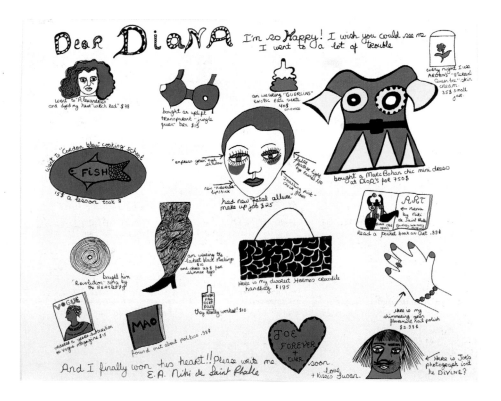